艾未未

AI WEIWEI

© 2014 Assouline Publishing
601 West 26th Street, 18th floor
New York, NY 10001, USA
Tel.: 212-989-6769 Fax: 212-647-0005
www.assouline.com
Printed in Hong Kong. ✆
ISBN: 9781614281917

Cristina Carrillo de Albornoz Fisac

AI WEIWEI

ASSOULINE

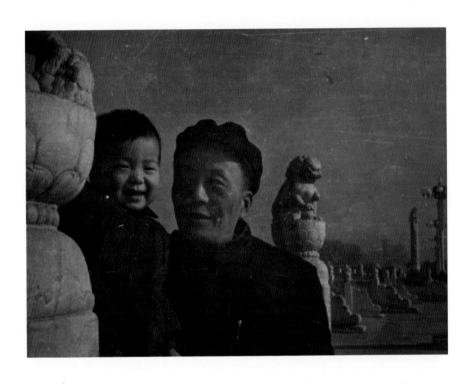

A

ACT

"Act" is my favorite word. Creativity is the power to act. It counts to take action; a small act is worth a million thoughts. That is the most important lesson of my life. Your own acts tell the world who you are and what kind of society you think it should be.

AI

"Ai" is a very uncommon family name in China that almost no one has. [It seems it is a shortened form of Aisin Gioro, the family name of the Manchu emperors of the Qing dynasty, who ruled China until the Xinhai Revolution of 1911.]

My father, Ai Qing, was a poet—one of modern China's most renowned and revered—who changed his name. He was born Jiang Zhenghan; when he was in his twenties he was sentenced to six years in prison by the Nationalist Party [KMT] for his literary views, but he continued to write. However, he found so execrable the fact that he and the leader of the KMT, Chiang Kai-shek [Jiang Jieshi], had the same surname that he made up an alternative, pronounced "Ai."

The pronunciation of the surname "Ai" is exactly the same pronunciation as the word "love" in Chinese.

As a young man, my father studied Baudelaire and Mayakovsky in Paris in the 1930s; he talked of art, such as the Impressionists. Coming from a poetic family, the roots of poetry are in all I do. However, I admire him mostly for his strong soul and powerful thinking, accepting a kind of jailed human condition. After his years in prison in the 1930s, he was sent at the end of the 1950s into exile to Xinjiang, a remote western province in China; our family went into exile with him. I was two years old and I grew up in labor camps. My father, who was by then sixty years old and had never done physical work in his life before, was forced by the government to clean public toilets for sixteen years in very hard conditions; there was hardly any water to clean with. In summer the temperature was above 40 degrees Celsius, so the smell was terrible, and in winter we had 30 degrees below. When I was ten years old I helped him to clean; besides, at night I would roll his cigarettes to mask the smell, using old receipts to roll them in. He was very patient and cleaned very well. He had to sanitize about thirty toilets every shift and he left these rooms like as if they were minimalistic works of art. He felt a joy and smoked another cigarrette and looked at his work, felt satisfied with what he had done, starting a new row. Every corner was beautifully set, but the next day it was the same again, terribly messy. However, the worst was the women's toilets; I even got shit around my neck. But if you grew up in that place, you do not feel that sad. I was so impressed by what he did to those toilets! He survived with dignity. It was his statement.

The people of this village tried to shame him; they didn't recognize intellectual value. I have lived with political struggle since birth. As a poet, my father tried to act as an individual, but he was treated as an enemy of the state.

When I think about him and other people, I feel very strongly that I want to show my opinions toward this society. So many people of his generation sacrificed their lives!

If someone is not free, I'm not free. It is some sort of poetic feeling, but I do feel this is so.

ART WORKER

In the Cultural Revolution there were no artists. They were called "art workers." I like the name very much, but no one calls themselves "art worker" anymore.

During my detention two years ago, the authorities asked me, "What's your profession?" I responded, "Artist." They laughed. "Ha, ha. You can't call yourself an artist." I said, "So what do you call me?" They replied, "At most, you are called 'art worker.'" I agreed. "Okay, I'm an art worker."

ARTIST

I've never planned any part of my career—except being an artist. And I was pushed into that because I thought being an artist was the only way to have a little freedom. I needed to escape.

Art is not about hanging pictures in an art museum, it is about magic. We cope with our lives, so we should not be away from our consciousness and our passions. Art gives us access to it.

Art has to ask for new possibilities and to try to extend existing boundaries.

B

"BAI JU GUO XI"

I like the idiom we use in Chinese to express the brevity of life: "*Bai ju guo xi*"—the moment a white foal takes to jump over a crevasse. Life is a value in itself, and every dictatorial attempt to steal its surprises and cut its possibilities is a crime. Our existence as such is accidental, and we should appreciate it.

BICYCLES

Back in my childhood, in my village, the most admired person was the one who could get a bicycle. They were so durable, made for the country roads. So I had to learn to ride bicycles before I could even pass my leg properly over the bar, which was too high; I looked like a cripple. I used to go for rides to collect roots from the woods and then load the bag of roots into the back of the bike. I took it home, which was far away, and I felt happy all the way back thinking of how proud my mother would be when she saw me. The farmers in the village were always watching: *Look at the boy.* After, I arranged the roots in front of the house, in a very neat way, as if it was a sculpture.

The bike was our luxury. They would not pay attention to a Mercedes-Benz; a bike was much more glamorous.

BLACKJACK

I am a very good blackjack player.

Playing blackjack was a source of income for some years in the States. I went to play in Atlantic City. It helped me to survive in difficult times. In fact, only when you want to survive can you become very good, because you cannot afford to lose. Once you lose, you can never go back to the table again, you know? So, always have some stakes. I think that's the one most important rule of the poker game.

BROTHER

My brother [Ai Dan] used to say, "Your beard is your makeup." When I was in the USA, he and my family often could not recognize me because my hair and my beard change constantly and dramatically. Now it is always the same.

My parents were married, they divorced, and remarried. They have my brother and me. Besides, we have two half brothers.

My brother lives with my mom in the city.

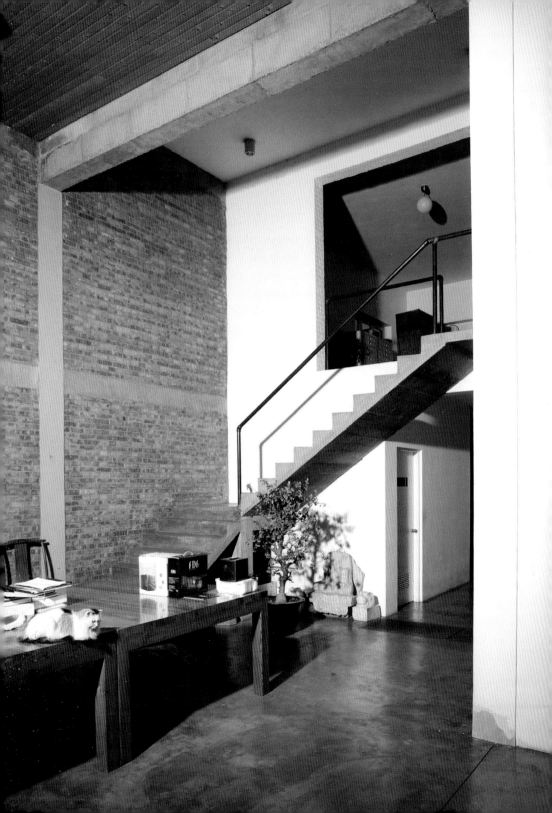

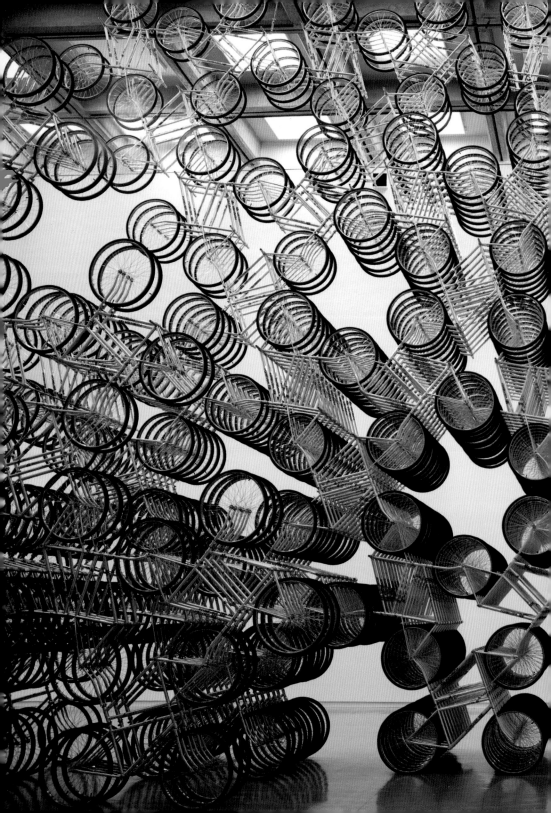

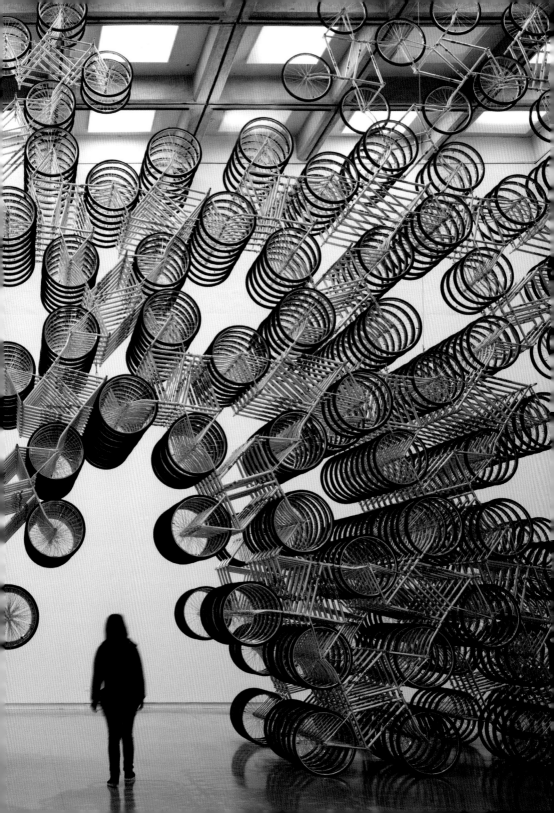

C

CATS

I like cats for many reasons. First, a young volunteer student from a conservationist group called my attention; he told me 400 cats were in a warehouse and would be sent to market to be sold for meat, to be cooked, and for fur. So I went to see and the view at the warehouse was terrifying. The cats had been stolen from many places by people who sell them; they were badly treated and piled up together. The natural desire to save a cat is what it means to be a citizen.

In my studio I keep more than fifty cats.

Cats are very special. They are independent, cool, elegant, and they only come to you when they like to; they will never accept orders from anyone. They are always very clean and very efficient. They can catch a bird in the tree; they also seem to be meditating in a corner. That is why there are many cats in my studio. These were abandoned cats. Now they are very clean and have a vet who checks them out.

CHOICES AFTER WAKING UP:

1. To be part of life or a part of death. 2. To want truths or to want lies. 3. To be happy or to be rotted. 4. To love or to be abandoned. 5. To be wise or to be brain-damaged. 6. To smile or to be humiliated. 7. To condemn or to celebrate. 8. To have more courage or to have more fear. 9. Zuosa or Sina. 10. To have freedom or to be imprisoned. (Tweeted by Ai Weiwei, "@AWW," 5.9.2009, 08:50:36, quoted from *The Unilever Series Ai Weiwei: Sunflower Seeds* exhibition catalog. London: Tate Modern, 2010, p. 45.)

[Author's comment: Zuosa and Sina are both microblogging sites in China. It is interesting to note that Ai Weiwei does not call Sina by its official name, which means "new wave"; he plays with homophones and calls it "stinky waves."]

CLEANLINESS

The scent of cleanliness is my favorite smell.

COLOR

My perception of color and sound are not good, maybe because of my early experience in the Cultural Revolution [1966–76]. China was a gray society, with no color, for many years. Only the red [stamps] existed. I connect red to violence and revolutionary passion, which is very brutal and against all sensitivity. Besides, the only music we heard was the propaganda music imposed by the government. Therefore, although I have many good friends who are musicians, I have not listened to music and I have not a trained ear. But I love metal music and its energy.

CONFUCIUS? NO, JUST CONFUSED

When I am asked if I have read Confucius or if I am close to his philosophy, I answer: "Confucius? No, I am just confused!"

D

DICTATORSHIP

The biggest crime of a dictatorship is to eradicate human feelings from people. Be it joy or sadness, you can sense it. We could call it humanity.

DUCHAMP

In the art field, I have the highest respect for Marcel Duchamp. He opened a new, boundless road to me for creation.

I am a revolutionary at heart: I like rebels, not in the revolutionary sense but in the independence of thinking and intellectual liberty. I respect the brilliant and original minds who stand up to announce a

new idea or new possibilities or a new tradition. That is very admirable because only humankind has brain activity. That is why I love Marcel Duchamp's work; he provided a very original way of thinking and enlarged the concepts of aesthetics, morality, and philosophy. He gave a broader view about ourselves, even scientifically speaking; he always comes as a surprise. Someone like Picasso made a huge contribution at this time and had a strong imagination, but compared to Duchamp's intellectualism, Picasso's art was too physical and passionate for me. Marcel Duchamp gets to the essence of man; he was much more poetic and had a clear mind. Besides, he was a master chess player.

The first time I saw a work by Duchamp was when I arrived in the States in 1981. The first city I visited was Philadelphia, where I enrolled in language courses. In the Philadelphia Museum of Art, they have the best Duchamp collection, including some of his major works such as *The Large Glass* and *Nude Descending a Staircase.* At that time, I hadn't even one feeling about it whatsoever. I thought it belonged in a scientific museum. It did not look like what I knew of as contemporary art. Then I studied Jasper Johns and I realized he had strongly been influenced by Duchamp, and that brought me back to whom I consider the great father of contemporary art: Marcel Duchamp.

E

EATING

Eating is my guiltiest pleasure...

I like simple food, such as bread and butter. We lacked food when we were growing up. From a very young age, I had to fight for food. We tried to steal corn from cornfields and we ate dragonflies. We did not have meat, and this was ironic; we had so much land and cattle in our village, but all the land belonged to the state. We could only eat the

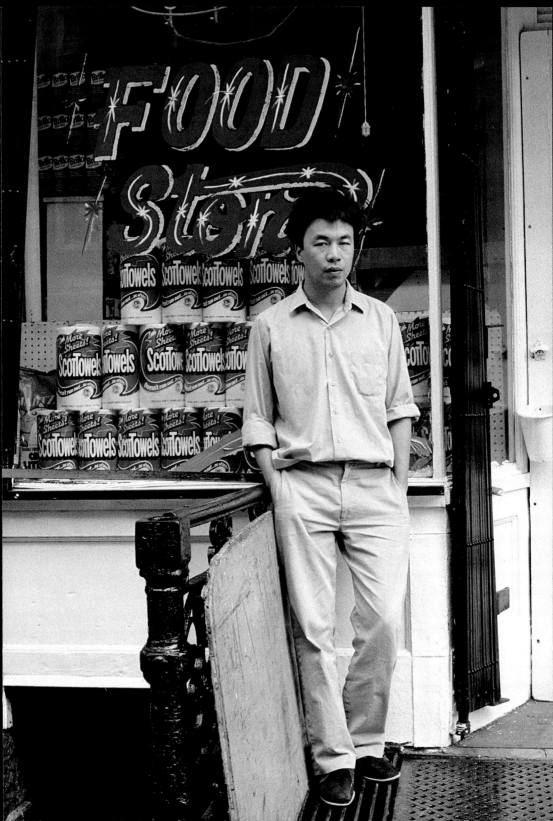

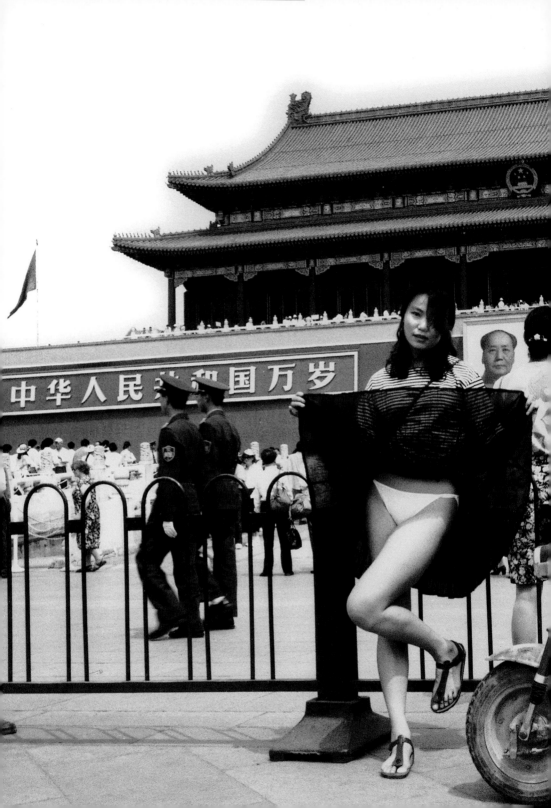

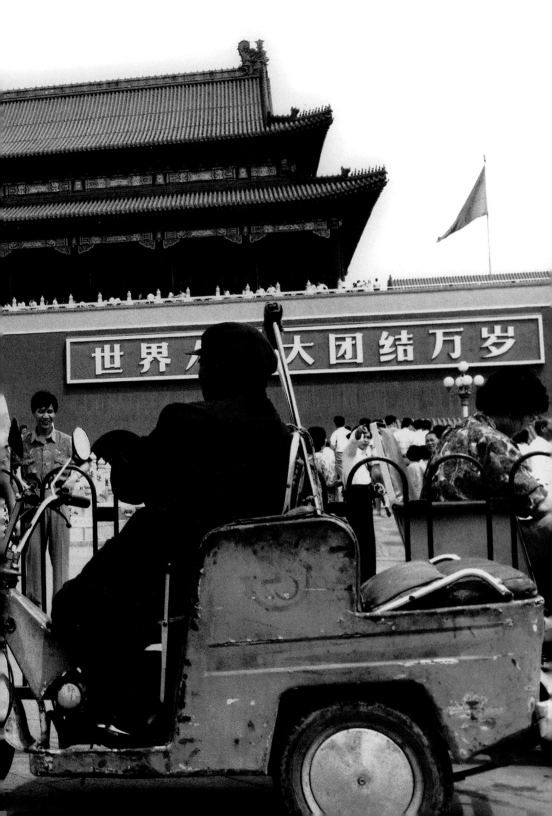

intestines and the guts, which we cleaned with soda and washed and boiled because it was basically shit.

When I went to live the States, I ate almost no hamburgers but I ate Dunkin' Donuts; I would order them by the dozen. They go very well with sodas. I remember I studied how the soda machines functioned and managed a trick to empty the whole machine for free. My old trick will not work anymore with the new sophisticated machines. It was a heavenly time. I was very skinny; now I am proud to have built up some weight and made a figure of myself.

EDUCATION

When I was under house arrest, I had to go every day to the police station to be "educated."

China is still in constant warfare, destroying individuals' nature, including people's imaginations, curiosity, motivations, dreams.

F

FAKE (FAKE CULTURAL DEVELOPMENT UNLIMITED)

This is the name of my company. It was a name I registered thirteen years ago. To have a company registered, you need to provide a list with a few names for them (the Industrial and Commercial Bureau in Beijing) to choose one from. We gave "shit," "pussy," "dick," and "fake." The authorities here do not understand English and they said the three first names seemed foreign; "fake," a very unassuming name, seemed fine for them. But said out loud, "Fa-ke" sounds as close to "fuck" as is possible in Mandarin. So my company was called "Fuck Cultural Development Unlimited." I have developed a sense of humor; it is vital to survive. Dealing with the state you can not be too serious. It became like a joke.

FREEDOM OF EXPRESSION

It has become my main struggle in life. To underestimate freedom is an insult. Freedom is what I value the most. It is such an abstract word, but it's all we need.

FUCK OFF

When I came back from the States to China in 1993, I felt terrible, mainly because since the Tiananmen massacre in 1989, nothing had changed. So I went to the square and I took this photograph flicking my middle finger to the Forbidden City in Tiananmen. My statement with this gesture was: *I, the individual, can in my own way show my feelings toward a powerful state.* My idea: *You can still be powerful, but I can still be me.* After the Berlin Wall came down, I realized there would be a constant struggle between the individual and not only the state but any power, whether cultural or economic, institutions or corporations... So I decided to do other photos with other backgrounds of prominent architectural monuments such as the Eiffel Tower and the White House. It is boring to go to places and take photos of yourself standing in front of monuments; and I feel shame to live in a country were you cannot lift your finger. Anyway, I am always critical in China and elsewhere. Wherever there is power or establishment, there is corruption and a rotten part.

That was my small symbol and I feel it has become today off-limits. My middle finger has become famous.

It was not a spontaneous gesture. I was a shy young man and I never did swear or say a bad word to anybody in my life. I will tell you a story from when I was a boy. My father was a literary man, an intellectual, and my family had a better life than the street boys. They would say to me, "Fuck your mother." I did not know what it meant or how to use those words; however, I thought I had a better and more complicated language than them, and I would reply, "Fuck you and my mother,"

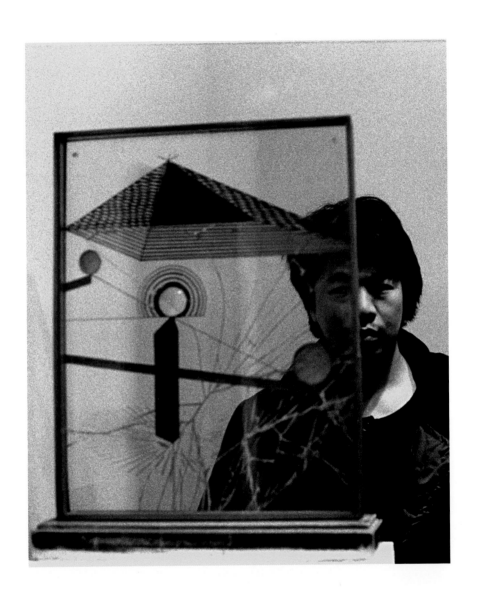

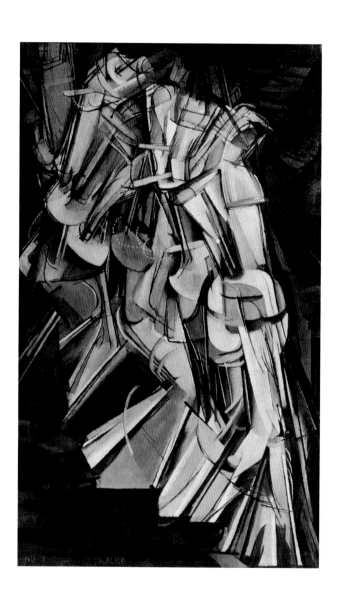

essentially turning it around on myself. I was a four-year-old boy and my elder brother slapped me, telling me off; he would exclaim, "What are you saying?!"

G

GERMANY: THE FIRST COUNTRY TO RECOGNIZE MY ART

I have a special relationship with Germany, since my art was first received and recognized there. I do feel very grateful to Germany for their willingness to accept and to listen to arguments. It is a nation which welcomes discussions and other concepts, and they take it seriously. They are very open-minded. This is a very fortunate thing in this world. Germany has always encouraged me and has given me a lot of freedom and support, which is vital for creativity. In that respect, I had one of my major shows in Germany, at Documenta 12 in Kassel in 2007.

It was called *Fairytale,* [a gigantic construction of 1,001 wooden doors and windows from destroyed Ming- and Qing-dynasty houses] for which I brought 1,001 Chinese citizens to Kassel. The significance of the number 1,001 is that it is one person more than one thousand, to try to emphasize individuals rather than groups. To me it would suggest and relate to collected individuals rather than a group. It represents individual consciousness and awareness. I want people to see their own power.

That is why I am really proud of that show. That project was very difficult; I did not know how it was going to result. I remember I was very worried by many small details, like how were all these 1,001 people going to obtain a visa: They were mostly coming from remote poor towns, women who had almost no name, minorities... In light of the regulations to get a visa in China [bank account, letter from your

working unit, etc.], it seemed impossible. I had a meeting with the German ambassador to explain my project in Kassel and my problem. After five minutes he informed me that he would provide visas for all of them. It was a difficult decision for any nation; almost a miracle that he would take the responsibilities and consequences, and this impressed me the most. Normally diplomats are not so clear.

GOING HOME

It was 1981 and I was twenty-four years old. I decided to leave for the States, helped by a girlfriend who had relatives there. I had to make my life and find a place of my own. I had to search for my own happiness. I told myself in the Beijing airport on the way to the U.S., *I will never come back.*

I told my mom, *I am going home now,* and my mom exclaimed, *You do not understand a word of English, you do not have money, and you are going to the U.S.? How are you going to survive?* I replied: *Do not worry, mother, I am going home.*

I felt happy from the first week in the U.S. I was in Philadelphia and I started knocking on doors to show people I needed work; the ladies who opened the doors were surprised to find a Chinese boy. Philadelphia is an old town, and at the time there were very few Chinese there except in Chinatown. They accepted me and welcomed me, saying, *OK, you can help out to clean the house.*

I had such a warm feeling about my first connection to the Western world! They were generous, opened their homes, and gave me a job and paid me. I was house cleaning; it was the only thing I could do and I was very good at it. They asked: *How do you work so fast?* For us, in a Communist country, in order to appreciate a work one needs to work fast. I still remember going to work with farmers in Xinjiang; they worked so fast I could not catch up with them. The fields in Xinjiang were very vast, thousands of acres large. You had to see the other end like if you were in

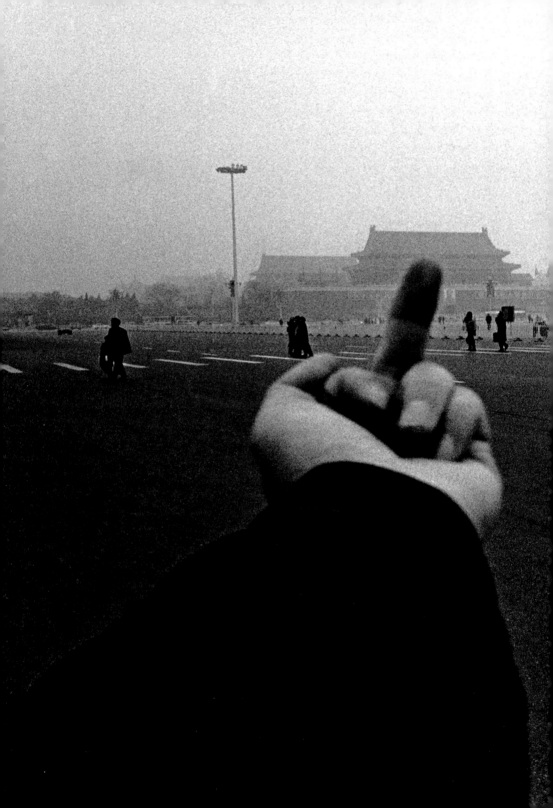

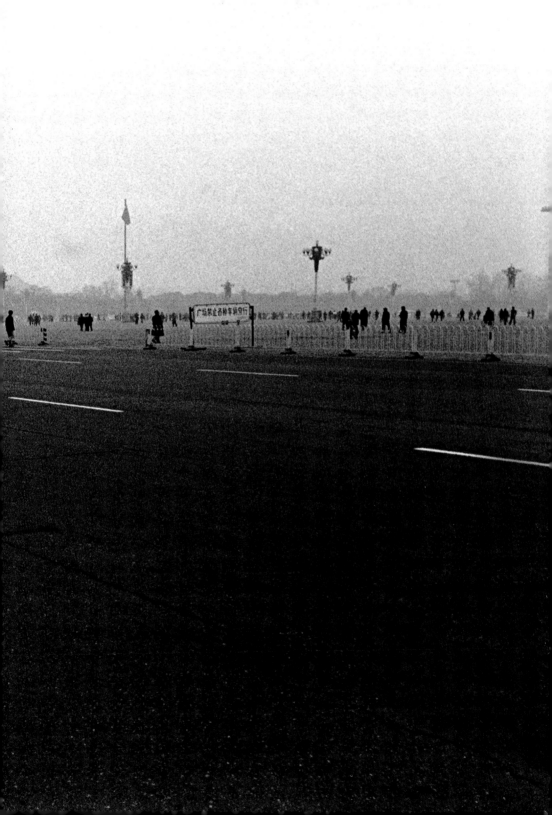

an Olympic map. I did all kinds of farming jobs and I had kept that spirit. I cannot work slow; it does not give me joy to work slow.

In the States I was paid $3 an hour. So instead of finishing in one day, I finished the work in half a day and did two houses or more per day.

HAPPINESS

Happiness can't be faked.

I have a lot of joy and I live as a man who just enjoys the present moment. I am always very content and I feel very fortunate; I do what I want and what makes me feel alive. For me, life is one day; it is like a walk in the woods, tree by tree.

Living the present intensively is my privilege. It has not always been so. I have neglected or not developed myself. When I went to the United States I spent twelve years doing nothing, and when I came back to China I spent almost another ten years with nothing to do. Playing cards to kill the time; shuffle, deal a new hand.

Looking to the past, I grew up in a very difficult situation. In China happiness is always being taken away from people, but every day we can try to create laughter and bring happiness to others.

And now in my hard circumstances, many people ask me how long am I going to go on [fighting for justice]? Or why I do not take care of myself and avoid unpleasant situations. They might be right. Now it might be sometimes difficult or dangerous or greatly uncertain, but at the same time I start to feel that past experiences can help. I think about other people's experiences and mainly about my father, who was forced by the government to clean toilets in very hard conditions; I am a private individual but I am not alone. It is not a bad feeling.

In my fifties, I am living the most challenging time of my life and

I am still alive and I can appreciate small wonders such as the light coming through the window. I am grateful to have so many wonderful people supporting our struggle and who recognize justice; this shows a great concern about the world we live in. Especially after my detention, I started to get recognized in public, which shows that people care about art and essential humanitarian values and the freedom of speech. Those values are still fragile and have to be fought for. These reflections give new strength to my work. But I'm still very happy, with even temperament.

I'm alive and full of passion and energy, which are gifts. So I feel I have to keep on "making noise." That's beautiful enough.

HOLLYWOOD FILMS

During my twelve years in the United States I experienced and learned so much through art on the Lower East Side or demonstrations. All those things I watched, I never [thought] there was an influence. It was only when I was in detention in 2011 in China for relentlessly criticizing that I realized I had been influenced.

During the interrogations by the police, they said, "Ha ha, you must watch too many Hollywood movies such as *The Godfather* and *Mean Streets*." It is true I love Hollywood movies; I still can be touched if I watch movies. In a certain way they have changed who I am.

[In 1978 Ai Weiwei enrolled at the Beijing Film Academy.]

I

IINDIVIDUALITY AND THE INTERNET

My philosophy is: *I am myself, I am different from all of you.* Therefore, the act of questioning the status quo is a healthy impulse. This is the aspiration to be different that I refer to. Individual power

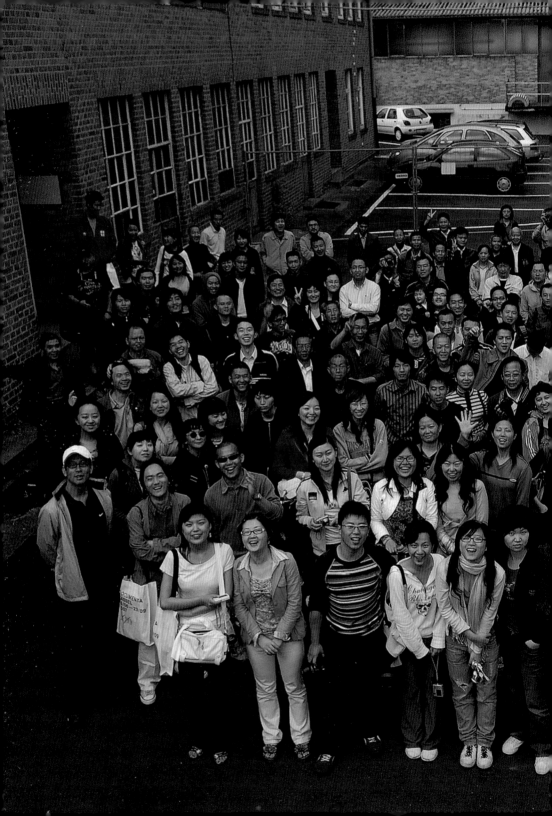

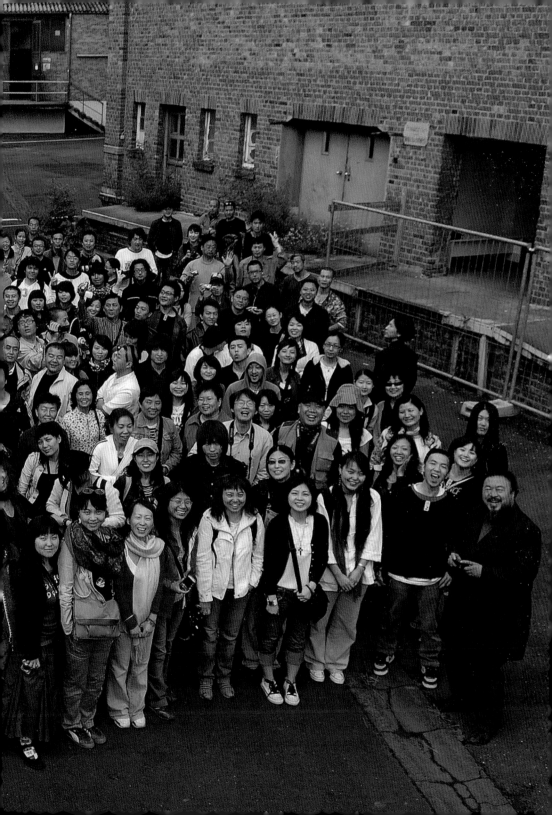

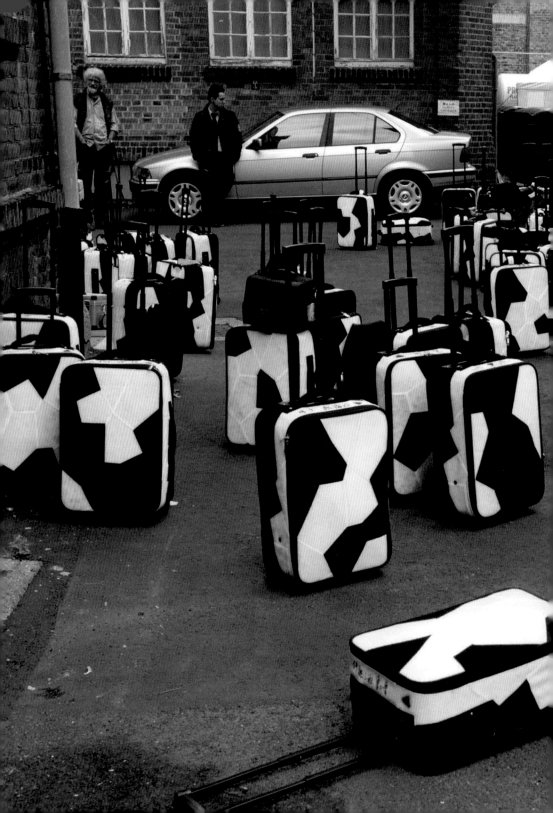

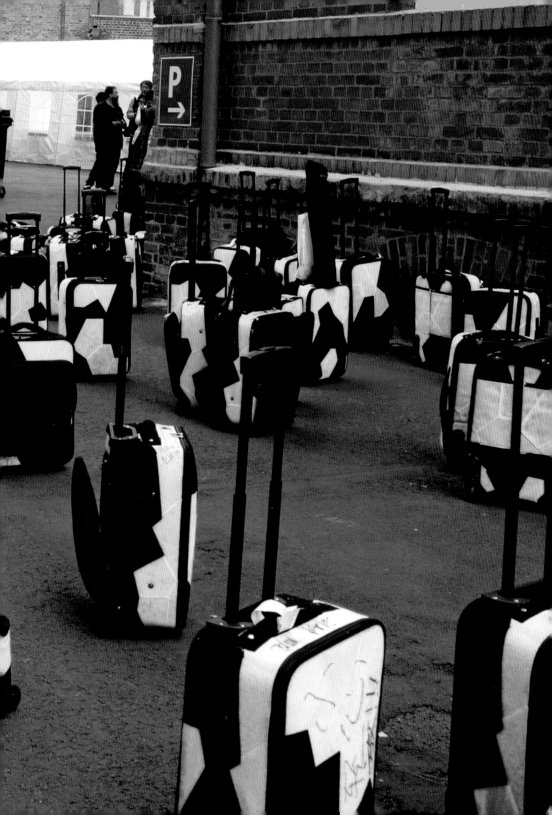

versus state power—how far can individual power go?

My American experience quite influenced my understanding of individuality, basic human rights, the rights of freedom of expression, and the rights and responsibilities of citizens.

Then, later, I learned everything from the Internet. I learned to discuss, to communicate, to make a point through modern technology. The Internet is my way of living and communicating. It can transform you. There is a lot of poetry. It is beautiful because it is larger than life.

So maybe there are three parts to my life—my earlier background living in exile in Xinjiang in a very political circumstance; then in the United States between 1981 and 1993, from twenty-four to thirty-six years old. I became quite equipped with liberal thinking. Then back to China, then the Internet. If there is no Internet, of course, I cannot really exercise my opinion or my ideas. The Internet is about how to act as an individual and at the same time to reach massive numbers of unknown people... I think this changes the structure of society all the time—this kind of massiveness made up of individuals.

J

JAIL

My experience in jail was brutal, hopeless, and dramatic.

I heard the soul can be killed by loneliness, by coldness, by absurdity. I suffered from all that, but the most terrifying was psychological threatening, being cut off from any reason or anger or fear... My cell was isolated. In solitude, but at the same time you're very restricted. I was alone 24 hours a day with two guards 80 centimeters away looking at me all the time. The guards had no expression. They were very young and clean and emotionless, like you were not there, like it was some kind of medical center.

I was in jail 81 days, but after 20 days my brain became completely empty; you need information to stay alive. When there's no information, you're already dead. It's a very, very strong test—I think more severe than any physical punishment.

All I wanted was a dictionary, even the simplest one.

JASPER JOHNS

When I just started to study art, a very well-known Chinese translator, Yang Xianyi, who translated most of the great pieces of Chinese literature for the West, gave me a book of Jasper Johns' paintings, and I could not understand it. The painting is about red, yellow, and blue and some brushes and some containers. So I threw it away. I gave it to friends and they also [didn't] want it. Then after I went to Parsons [School of Design], I looked at Andy Warhol, because he is so easy to understand. And then I realized Andy Warhol made some points about Johns and [Robert] Rauschenberg, because he always wanted to be accepted by Johns. He would always pop up and Johns [would be] very cool to him. And he didn't recognize Warhol that much.

So I looked at Johns and realized he is really an artist for the artist. He is really concerned about very essential language and the meaning of interpretation and the way to really look at [Ludwig] Wittgenstein and [Marcel] Duchamp. So Johns allowed me to take another step to look at what Duchamp did, which is the intellectual part of art, concept, and language. That is why I do feel quite grateful for what Jasper Johns did.

K

KITE

The Forbidden City is a very special architectural-landscape building, but it does not bring me joy. Today you cannot visit it in good conditions,

because there are too many visitors. Back in the 1970s I went with some friends inside the Forbidden City and we played with kites, and I felt how the emperors lived a good life inside there.

L

LOVE IS ALSO A RELIGION

Love has become more and more important in my life. When I was a young man I had a lot of anger. I had a lot of reasons to feel angry, obviously as a result of being deprived of the possibility to show any kind of tenderness, softness, or inner love, even to my parents or friends or anybody. In Communism, we had to be military types, always keeping our distance; we had to criticize so-called weaknesses. Love was very powerful, but considered a synonym of weakness in Communism; it was antirevolutionary. In every unit, the most beautiful and sensitive women were cursed, were taken out to the streets, had stones thrown at them, and they were insulted... until their hearts were broken.

Love is also a religion.

Now that angry man I was, is much less. I am much more relaxed. I have gone far away. I was beaten [by the police] and taken to hospital as a result. I had surgery in Munich by a wonderful doctor who did not even let me pay the bill. My studio in Shanghai was knocked down and I was arrested and treated badly. With time I realized the destruction of my studio was not the end but the starting point of something different.

LU QING

I am particularly fond of a photo I took of my then girlfriend who became my wife [Lu Qing]. On the fifth anniversary of the Tiananmen Square massacre, on June 4, we were able to move through rows of

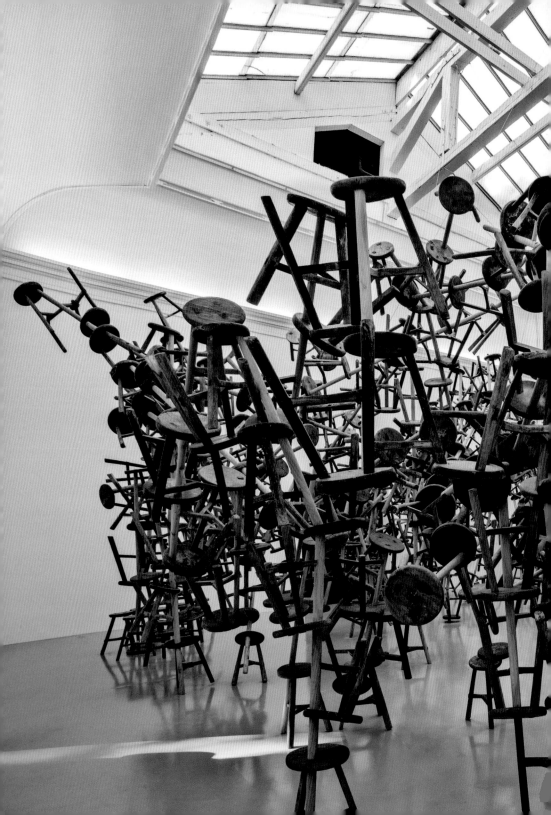

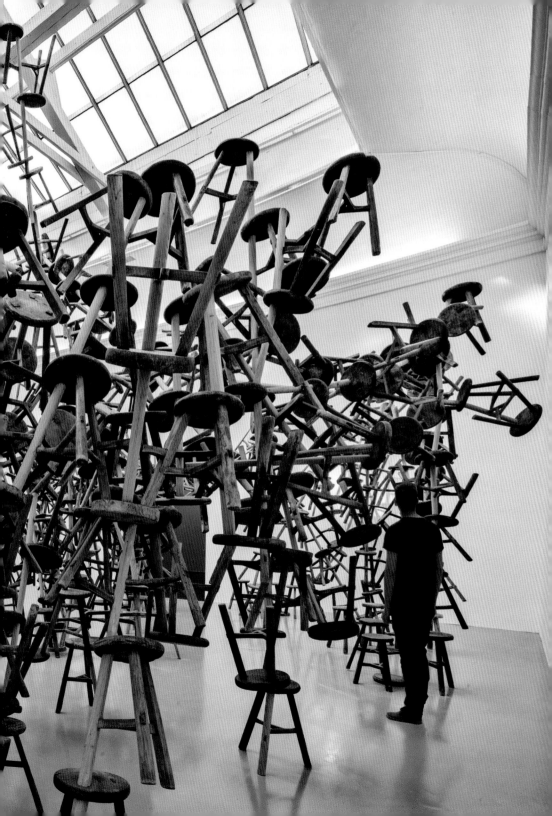

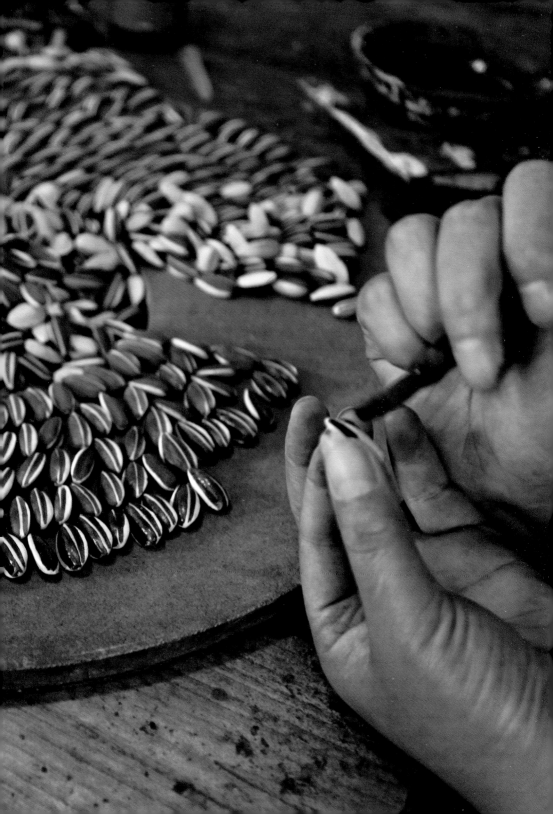

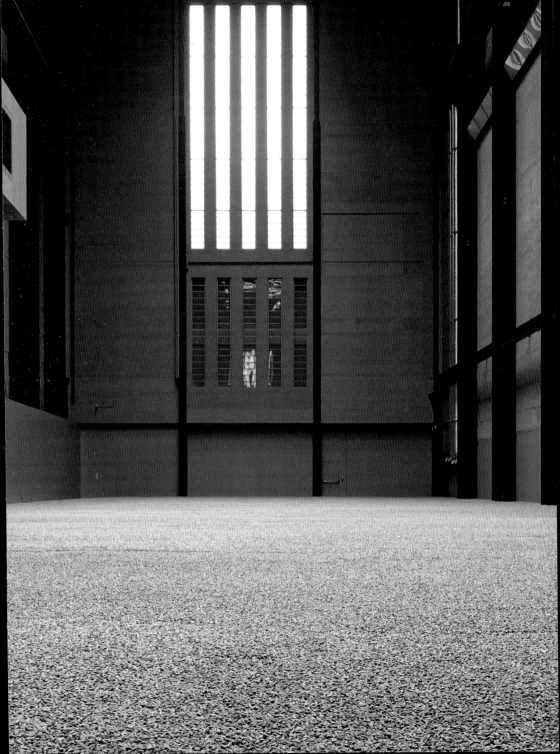

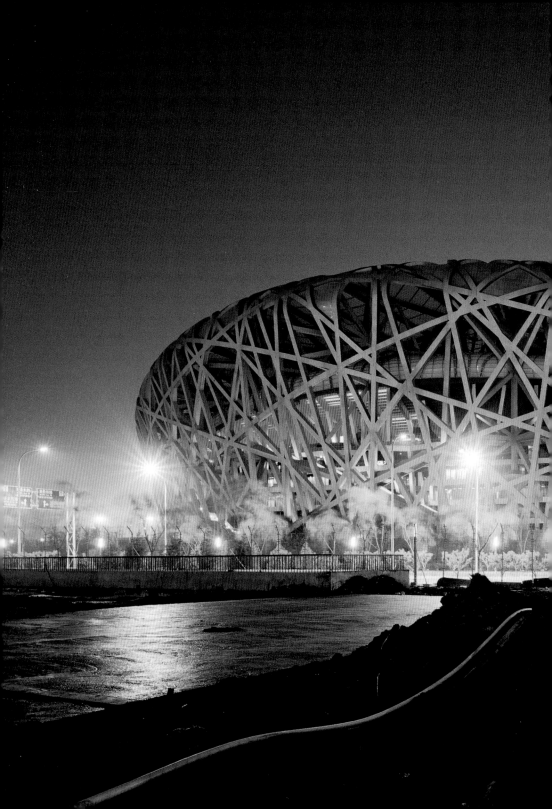

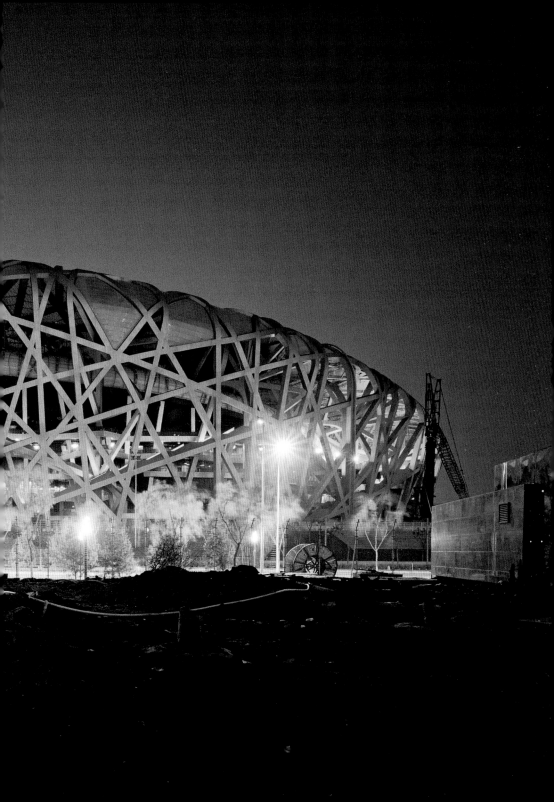

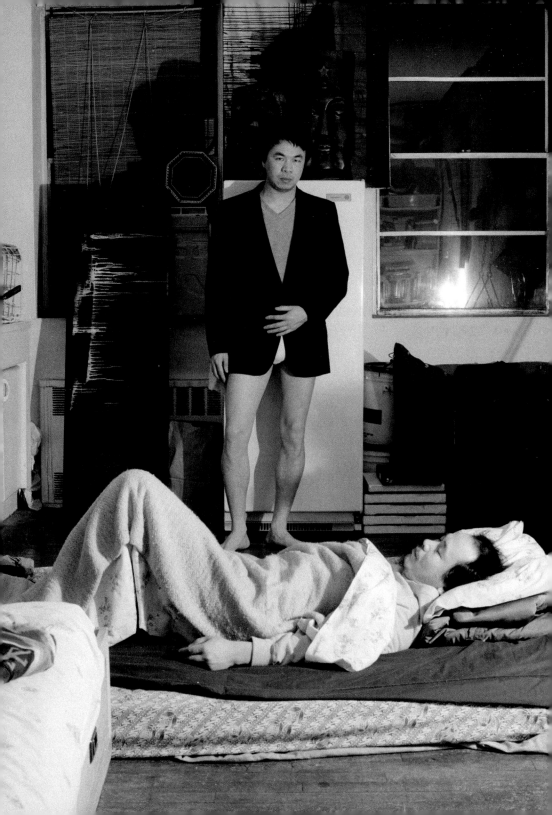

police and plainclothes detectives to the middle of the square, opposite the portrait of Mao. I asked her to position herself in front of a fence, with Mao's face between her and another woman. I captured the moment she provocatively raised her skirt and revealed her underwear; it was like the Marilyn Monroe pose. She did not hesitate to do it; she is an artist and she understands very well, and besides, she was in love, and the only advantage you can take of love is by doing something together. Love is to give each other liberty to fulfill some kind of desire. To take photos like this shows I can be free. I feel shame that I live in a state where I cannot lift my finger. I did that photo myself and it is a similar statement but safer.

The photo was published in underground art publications throughout the rest of the 1990s. It was not meant to be an artwork, but I published it in the art publications we created. At the time there was nothing in China. I opened the first gallery of modern art in China and published the first art books. At those early times that was all you could do. There was no other opportunity.

Lu Qing is a very good artist and she understands me and has always encouraged me. She works with silk, making a single new work annually. At the beginning of each year she buys a bolt of fine silk eighty-two feet long. Over the next twelve months, using a brush and acrylic paint, she marks its surface with tight grid patterns. The results look like grid drawings and traditional Chinese scroll painting. Some years she fills the cloth. Other years, when she can bring herself to work only sporadically, she leaves it half empty. But completion in any ordinary sense is not the goal. Her art is in the performance and meditation.

M

MAO ZEDONG

We grew up repeating the same sentences by Chairman Mao from day to night. It was a way of destroying the mind, dignity, and individual thinking. Using this kind of high ideological control as a tool to maintain power or stability is a completely fake condition.

I can only understand one of his ideas. Mao used to say: "Love and hate are never without reason." He may have been right, there. If I were a Western politician, I probably would like dictators, too. After all, they are able to make decisions very quickly and they will sign any check as long as you have a smile for them. Who cares about the conditions in dictatorships? Everyone has to make ends meet and you can't take care of everything, right? I understand this attitude perfectly.

MIND

What is important is what is in the mind. With a clear mind and no obstacles, you will discover that your resources are inexhaustible. This is because your heart is connected to and in harmony with the order of the universe.

MONEY

Deng Xiaoping encouraged people to get rich. China has become a paradise for consumption and new riches, sacrificing everything trying to make money; it leaves people bereft of morality, and with no sense of purpose beyond their financial potential.

China retooled the concept of the American Dream and changed it into a so-called Chinese Dream. It is an empty dream which belongs to the state rather than to the individual. A dream in which Chinese people don't buy one home but maybe twenty of them; they don't buy just a

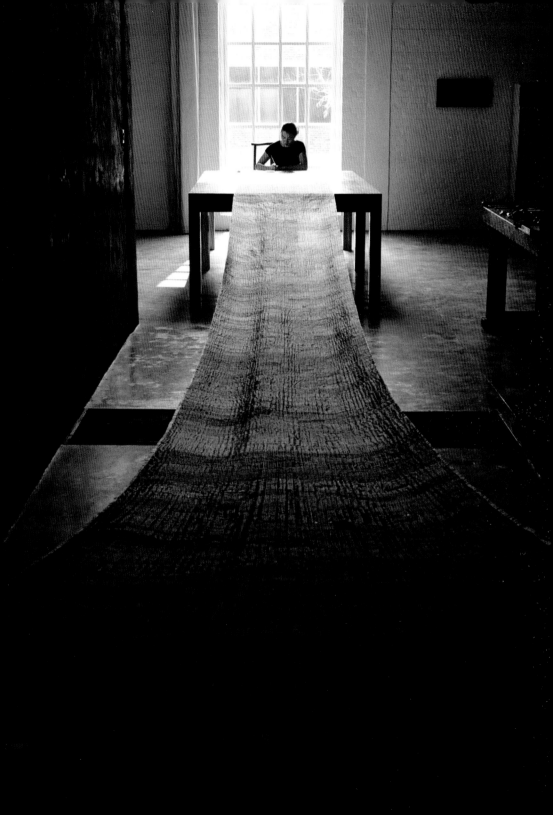

beach house but the whole street. Material life can't provide liberty or freedom, but just some kind of desperate ignorance or stupidity or a stage on which to display that. It completely destroys or, at least, delays the honest life. It only shows if you're dirtier, more shameless, more cheeky. You play this kind of game where you gain—I don't know what they gain.

I don't mind material change, but how people's minds change is the most precious thing.

A society with no values is powerless and poor and empty.

A society is alive by associating itself with real values such as justice, much more important for me to care about than where this painting sold, to which collector, which museum—I don't really care.

I am very privileged because I do not care about money... I think that can very much lead to misunderstanding and it can be misdirected to the commercial side of art.

N

NATURE

I relax by taking daily walks through a Beijing park. We are part of nature. I love to feel the sunlight on my face.

NEW YORK

When I first saw New York it was about nine o'clock in the evening, from the plane, just before I landed.

It looked to me like a bowl of diamonds, full of light. When I was a child we didn't have light or electricity; not even candles. However, I was attracted by the dazzling energy and imagination I experienced in New York, as well as by freedom of action and speech. Not by its wealth. I lived in the East Village for ten years, along with poets and musicians,

punks, Buddhists and Hindus, junkies and thieves. I was specially close to the poet Allen Ginsberg, who was a friend of my father's. It was a very carefree time, a bohemian lifestyle. I opened my eyes in the morning and didn't know what I would do the whole day. Every day, I had to create a new excitement and adventure. I took thousands of photos and visited all the museums. I became an expert at repairing cameras.

A city is strongest when it can reflect people's feelings, freedom, and desires. New York is a city of desire, for the powerful, and for beauty. But there's the American Dream—equal opportunity to be rich and secure under the law. People feel that nobody can touch them, because there's the law. Beijing is a city with none of these qualities. An artist can be taken away from an airport with a black hood, disappeared for eighty-one days. When a nation can launch a satellite but cannot give a clear sentence about what happened to me, that scares people.

My experiences from New York are very important for me today. It gave me a basis for my contemporary thinking, and thanks to this basis I can function well today in China.

NOT POSSIBLE

When people say, "This is not possible," that encourages me because it is in my nature.

NUDITY: BEING NAKED IS CLOSE TO ZEN

I have no taboos, and posing naked is a way of being liberated from censorship. My spontaneous and carefree attitude in nude performances could be seen as a joke, but they also come close to the clownish aspect of Zen. There is a certain theatrical aspect in Zen Buddhism, with abrupt language and actions. Irreverence is very important. And the chivalrous tradition, originating about 2,000 years ago during the Han dynasty, stresses a few basic values, which come to bear on my championing of basic rights.

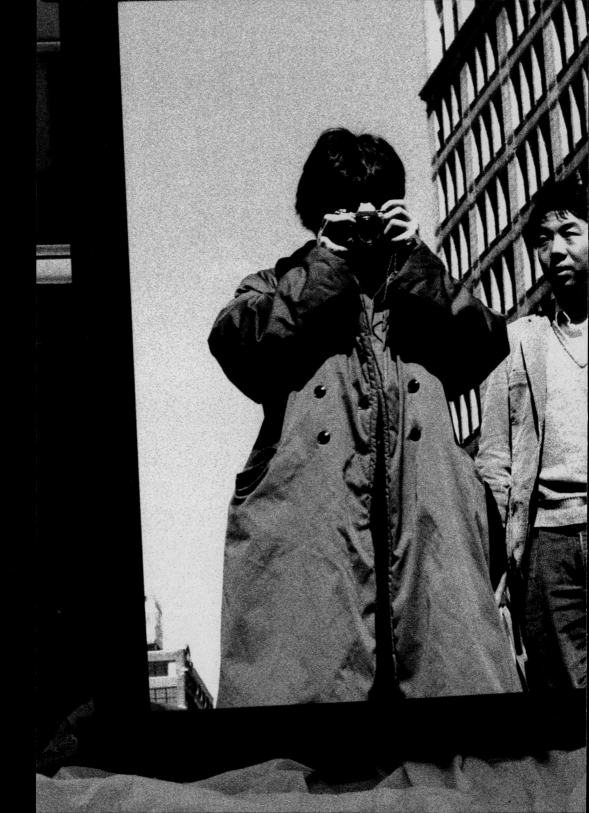

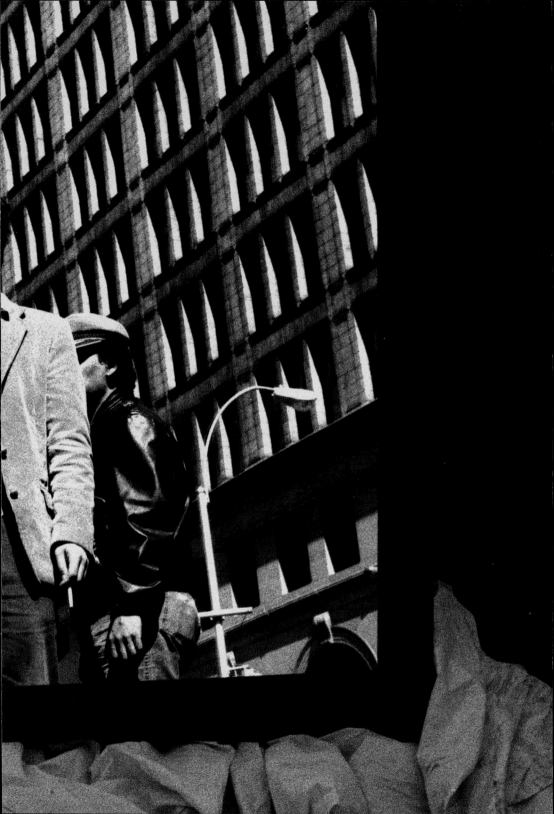

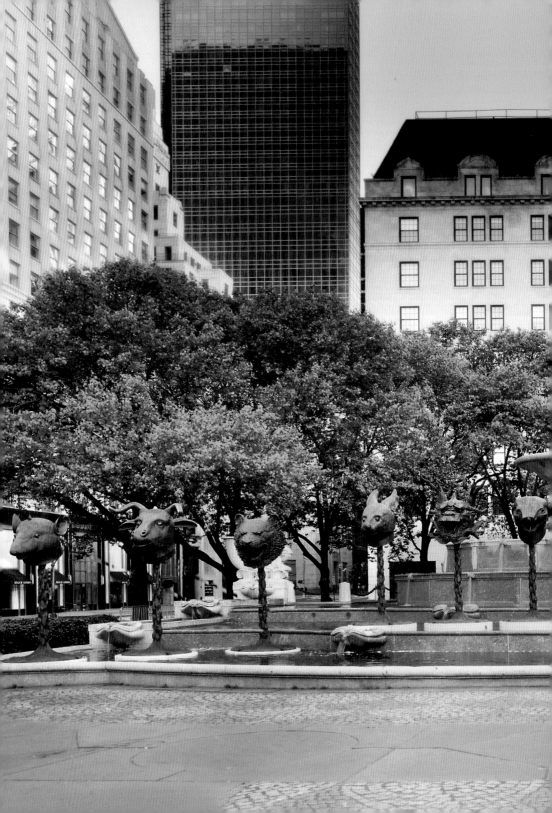

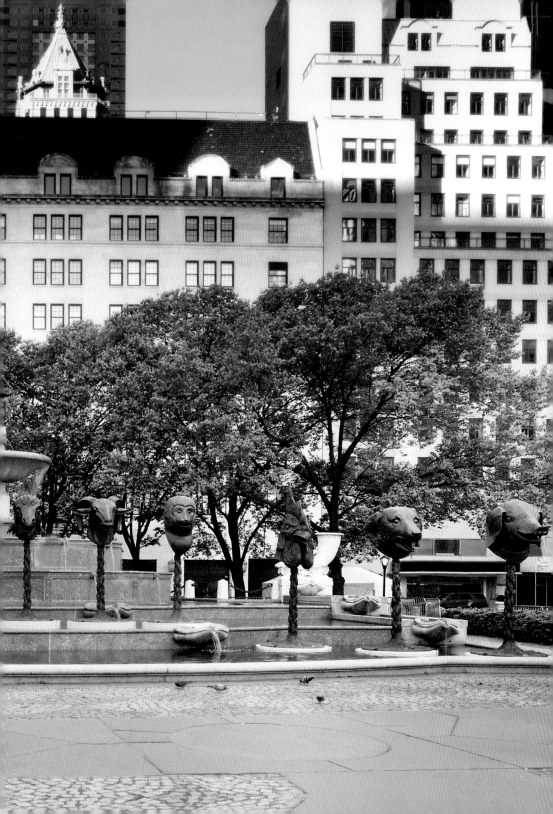

My nude projects may have as well some spiritual common ground with aspects of Zen and chivalry in ancient China. Some Zen monks liked to bare their chest and shed their clothes. Zen carries a tradition of seeking direct access to the heart and soul, stripping away anything else. "See the basic nature and attain Buddha-hood" is a known phrase.

O

OUTSIDER

I was always also a shy person when I was growing up. I became more and more "brutal." When you are shy you do not know how to participate. You feel somehow an outsider, not feeling comfortably accepted. You start to be too self-conscious of that difference and are shocked... I am too old to feel like that. My luck is to be finally like I am. We have to make ourselves be as we are.

P

PATIENCE

Patience is the most needed human quality. I believe we humans are never patient enough.

PICASSO

When I was leaving for New York, on the way to the airport, my mom was really worried. I told my mother, "You will see another Picasso in ten years."

PORCELAIN

Porcelain is a material of my art. I had studied and dealt in porcelain antiques.

I like my porcelain crabs. [He created a work called *He Xie* composed of 3,200 porcelain crabs.] The pile of crabs was a protest in response to the November 2010 destruction of my new Shanghai studio. The day of its demolition we prepared a party with 10,000 river crabs, but in the end I was under house arrest, unable to attend.

What makes them more than merely technically interesting as ceramic crustaceans is that the word "river crab," a homophone for "harmonious" in Chinese, has become an Internet term for online censorship.

Q

QING AND MING DYNASTY SOPHISTICATION

My art language has a lot to do with the relevance of the past and its importance in the present.

In many of my artworks I use ancient pieces of furniture, ceramic, or jade. I am a real connoisseur of Chinese history. I have extensively studied the Ming [1368–1644] and Qing [1644–1911] dynasties (the Forbidden City was once their imperial residence), a time when culture, philosophy, aesthetics, morality, and craftsmanship all came together to create one harmonious whole. After I came back from the United States, between 1993 and 1999, I spent six years in antiques markets (mainly Panjiayuan Antique Market) looking for early pieces: stones, silk, wood, ceramics, furniture, porcelain, jade. I was a very successful dealer and not just because moneywise I had to make some money to learn and buy and research. Because I am a fast learner, it quickly became very repetitive so I stopped and I became an architect for another six years, and then I became an artist, and then I became an activist. It is always

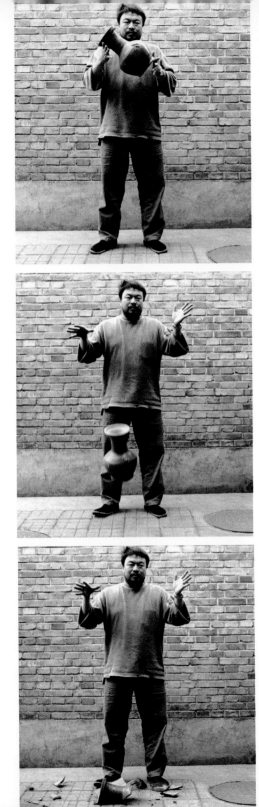

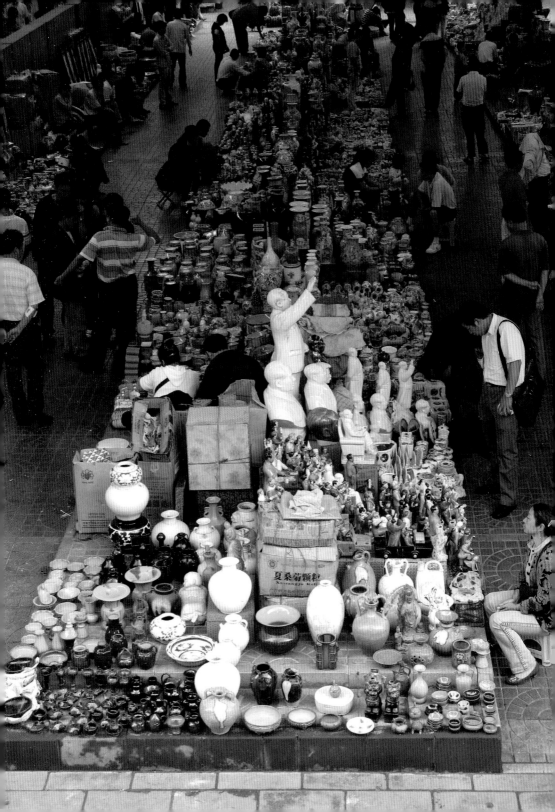

interesting to use old language and try to find new expressions, shapes, new definitions and sensitivities for it. Anyhow, culture, like it or not, is a continuity and it comes back to haunt us; we do not start from zero. They raped this nation's ideology and thinking for sixty years. The past has evidence of civilized language, and society is a product of civilization. It is important to see how they used different concepts and ideas, and that their skills were so refined. In the old times, they all sought perfection. Therefore commissions came from emperors or popes (the art of temples and cathedrals) to artists with a perfect understanding of light, volume, and space.

R

REMEMBER

Life has taught us, under totalitarianism, every day is the same. Every day in a totalitarian society is one day, there is no "other day," no "yesterday" or "tomorrow." We no longer need partial truth, we don't need partial justice or partial fairness.

Without freedom of speech, without freedom of news, without freedom of elections, we are not people, we do not need to remember. Lacking the right to remember, we choose to forget.

Let us forget every instance of persecution, every instance of humiliation; every massacre and every cover-up, every lie, every time we are pushed down, every death. Forget every moment of suffering, then forget every moment of forgetting. [...]

Forget the interminable lies, the rulers hoping everyone has forgotten, forget their coward[ice], their evil and ineptitude. We must forget, for they must be forgotten. Only when they've been forgotten can we exist. For the sake of existing, let us forget. [Quoted from Custer, "Ai Weiwei: Let Us Forget"]

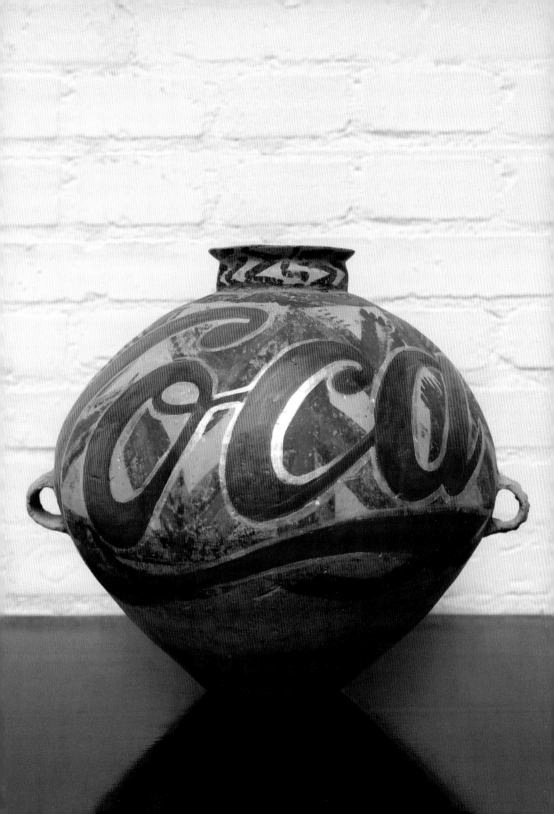

RESTRICTIONS AND REBELLIOUS MINDS

What makes me most unhappy are restrictions.

I admire rebellious minds. My father was a writer, a poet. I always appreciate people who can clearly state their mind. That is why I enjoy poets in all fields. Andy Warhol was a poet in the sense that there were no limits and no restrictions for him. Warhol has influenced me because of his writing. If I had never read his writings and interviews, I would never have understood his work. Those works are special to me because they state his mind so clearly. The first book I read was *The Philosophy of Andy Warhol (From A to B and Back Again).* I was very limited in starting to learn English when I read it, but I thought that book's humor was completely funny and cool. I thought, he's so sensitive and so uncertain, but with a lot of humor. Now I'm working so much on Twitter all the time: What are the sentences that I can put on Twitter?—very short but very smart and witty, and sometimes shocking. Well, a lot of the time it may be just nonsense...

S

SIMPLE: "MAKE IT SIMPLE" IS MY MOTTO

A simple lifestyle is one way of finding a path to Eden, so why do you want to develop so fast? Will you gain more at such speeds? I find both ideas very attractive, and I am constantly subject to their temptations.

SPIRITUALITY

I like to talk about a kind of spirituality, something maybe unexpected in a Chinese person. We are always wondering what we do not have in the material life, but I always wonder what do we have beyond, because we are much more than material, we have so much infinite space and

imagination. We are poetic creatures full of symbolic meaning.

Life is more exuberant, more meaningful than any style imaginable.

SUNFLOWER SEEDS: THIS IS THE MAN OF THE SEEDS

This is the man of the seeds: That is how people from Jingdezhen village called me, and I like it. One of my dearest installations is one I did for London's Tate Modern in 2010, called *Sunflower Seeds,* consisting of a 100 million hand-painted tiny porcelain sunflower seeds; although apparently identical, they were actually unique. Each handmade by a master craftsman, no two were identical. They were made in the village of Jingdezhen, where I was known as *the man who makes seeds* because the whole village was working on them. It's a work about mass production and the accumulation of individuals' repeated, small efforts to become a massive, useless piece of work. The installation was a carpet of life.

China is blindly producing for the demands of the market. My work very much relates to this blind production of things. I'm part of it, which makes it ironic.

In China, when I was growing up, we had nothing... But for even the poorest people, the treat or the treasure we'd have would be the sunflower seeds in everybody's pockets.

T

TEA: A TON OF TEA

Like most Chinese people, I am a tea drinker, although the first thing I do in the morning is drink water.

Tea is fundamental to our culture. Tea trading on the Ancient Tea Horse Road 茶马古道 (*cha ma gu dao*) meant tea traveled on the back of mules on precarious mountain roads for months from point of production to its destination market.

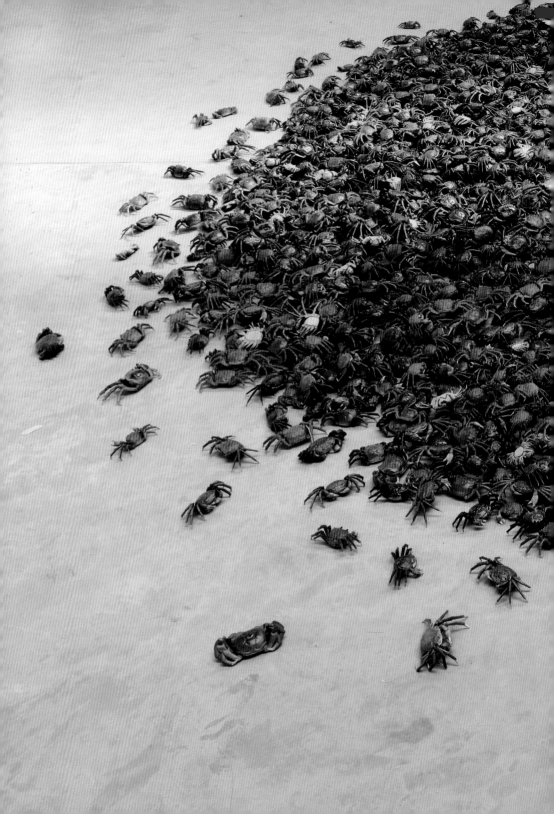

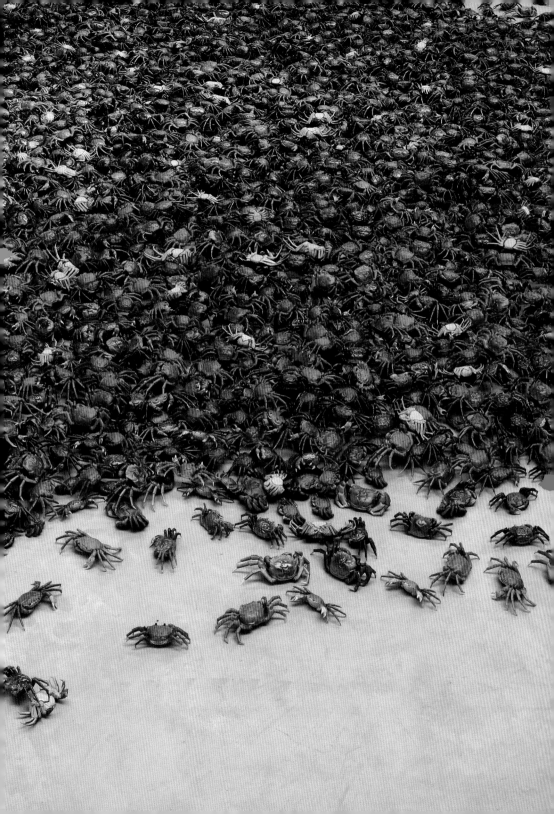

I decided to use it as the medium for one of my art installations, called *Tea House,* composed of one ton of compressed tea. It allowed me to challenge the past, and in doing so it became a way of changing the understanding and perspective of an object, disrupting its stability and making it questionable. I do the same when transforming or breaking ancient Chinese antiques: to question both the identity and authenticity of the object. It makes both conditions non-absolute.

It goes back to when I was a child and had to burn all my father's books during the Cultural Revolution. Those books were so beautiful. I burned them all in front of him; we had to. Otherwise it would cost us our lives. I tore every page. Beautifully printed books, art books he brought back from Paris. Page by page. Chairman Mao taught us to destroy, so I know how to destroy.

THREE YEARS OLD

I am fifty-six, but I do not feel old. I always joke on Twitter, saying I am three years old, because it is the time in life when you are most alert. My son is four, and I observe how he is very fresh and how mesmerized he looks at everything. I also am overexcited by many overwhelming experiences I cannot take in.

TWITTER

It is *the* tool: Most important political debates of the last decade in China have been initiated through the Internet. This medium has great potential to bring about social change.

I had used Twitter, YouTube, and Facebook to communicate my messages, to promote social justice and change in Chinese society; I don't think anyone can stop freedom of expression. They can restrict some kinds of behavior, but they can't restrict one's desire to express oneself.

U

UNPREDICTABLE

I am a free spirit, unpredictable, and that is why authorities fear me.
That is how art should be.

V

VAN GOGH

Art is my religion. Van Gogh, who worshiped art, said that art is a belief
system, not a decoration. I do feel it in the same way.

W

WEI

My name is Weiwei.

"Wei" is the pronunciation of the Chinese character 未, which means
"future" or "not yet." I wonder, is this a message?

WEIWEI FACTORY

I feel more creative in a team, and that is how we work in my studio.
I prefer the title "studio" to "factory," although it has a kind of simple,
factory-style approach to art making. We are a studio team, like a
collective wisdom. It's always nice to share your energy with young
people, the people who might not have any skills but are simply willing
to be a part of it.

There is a story about Warhol's Factory that I like. He really liked hard
work. He once heard that Picasso produced something like 4,000 works

in his lifetime, and Warhol said, "Okay, that's what our factory can do in a day." Then he realized, "Oh, I made a mistake. It will take us half a month, not a day."

Warhol is funny in this sense. When he's talking about art, he's talking about a lifestyle, an attitude, the people around him. It's not necessarily a beautiful product, but he himself is the Factory, the whole atmosphere. Warhol is about selling atmosphere. Once he said, "New York restaurants are about selling atmosphere." So, Warhol created this kind of mythology. I think that's very important, because only through that can other people be a part of it and share in it. That's why he's become legendary, because so many people feel they are a part of it. I think my work took that influence from him.

Y

YOU ARE A NICE MAN, BUT YOU'LL NEVER WIN THIS WAR

When I was in jail the authorities said many things to me, but there is a sentence that I find especially symbolic:

You are a nice man, but you will never win the war that you are trying to achieve.

They even think if I work hard I could be a good artist. They are leading my way; I am living up to their expectations.

Z

ZHONG GUÒ ("CHINA")

I guess I have a love/hate relationship with China.

I realize it is an unsolved problem. I live my life, but I feel I have a secret mission, as I was born Chinese, but at the same time I am refused [my

individuality] by the authorities here. My situation is very mysterious. Young people like me, but nobody can see my existence in public. Outside, I am a considered a Chinese artist or a strong voice, but inside they cannot even criticize me in China. The propaganda department has a clear policy: Nobody can criticize Ai Weiwei. They tried to dissociate me from this land that my father loved the most. He is seen as the modern, patriotic poet who belongs to the land and the national sentiment. All the leaders, from prime ministers to revolutionaries, they all memorized my father's verses of the motherland; I am the son who says *fuck your motherland.* What they cannot accept is how this guy—me—can say something so brutal and terrible.

The most popular verses from my father that they all memorized, including children at school, are:

Why do I often have tears in my eyes? It's because I love this land deeply and completely."

This verse could also be applied to this government, because they have sold every piece of land to developers!

But as long as there is land I want to keep fighting to promote social justice and change in Chinese society. My success will come when China changes. And I see now there is hope; China is ready.

China is my life's work, in a way my raison d'être.

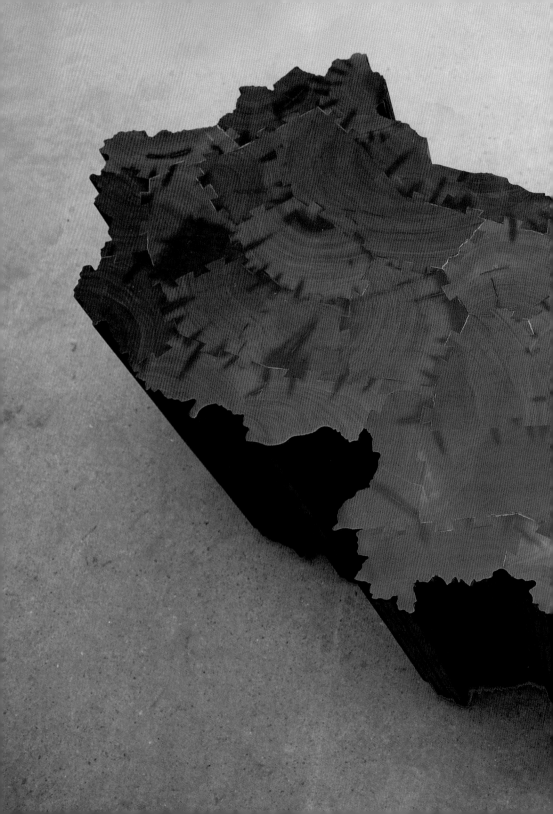

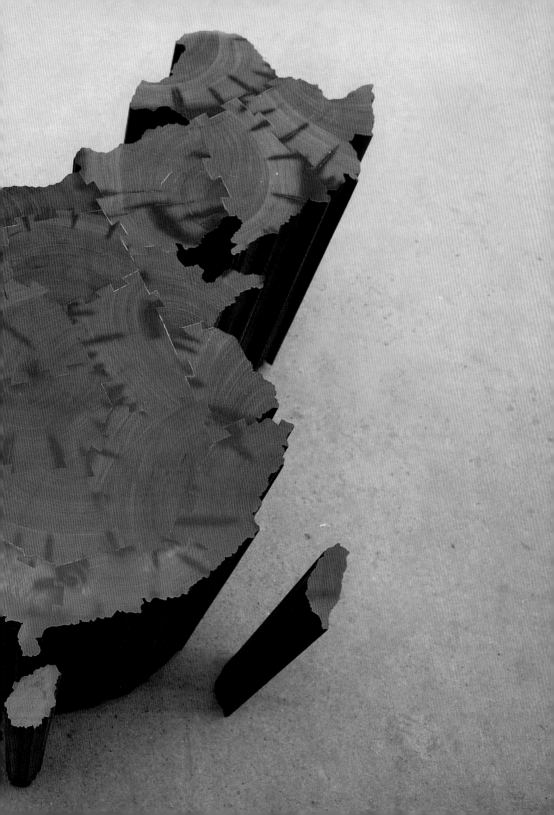

CHRONOLOGY

1957 Born in Beijing, China.

1978 Enrolls at the Beijing Film Academy; becomes member of the avant-garde art group the Stars.

1981 Moves to the U.S., living mainly in New York City for the next twelve years.

1982 Studies at Parsons School of Design, New York.

1993 Returns to Beijing.

1994–97 Publishes several books: *Black Cover Book* (1994), *White Cover Book* (1995), and *Grey Cover Book* (1997).

1997 Becomes co-founder and artistic director of China Art Archives & Warehouse (CAAW), Beijing.

1999 Moves to the Caochangdi district in the northeast of Beijing and builds the studio house, his first architectural project.

2000 Co-curator, with Feng Boyi, of the exhibition *Fuck Off*, in Shanghai.

2002 Curator of the Jinhua Architectural Art Park, Jinhua, China.

2003 Founds the architecture studio FAKE Design in Beijing.

 Is commissioned to design the Olympic Stadium in Beijing, with Herzog & de Meuron; construction finishes in 2008.

2005 Sina.com invites him to start a blog.

 Co-curator of the exhibition *Mahjong: Contemporary Chinese Art from the Sigg Collection*, exhibited in Switzerland, Germany, Austria, and the U.S.

2006 Speaker at the World Economic Forum Annual Meeting, titled Innovation and Design Strategy.

2007 Speaker at the DLD (Digital-Life-Design) conference.

Participates in Documenta 12, in Kassel, Germany. His project, *Fairytale,* invites 1,001 Chinese citizens to Kassel.

2008 Curator of the Ordos 100 architecture project.

Launches the *Citizens' Investigation* project to research information about students who died in the Sichuan earthquake May 12, 2008, and to investigate government corruption and cover-ups, following the collapse of so-called "tofu-dreg schools" in the earthquake.

2009 As of April 14, 2009, the list of names in *Citizens' Investigation* reaches 5,196.

Co-curator of the exhibition *The State of Things. Brussels/Beijing,* exhibited at Bozar, Palais des Beaux-Arts, Brussels, Belgium, and the National Art Museum, Beijing, China.

In May, blog is shut down by Chinese authorities after names of victims and numerous articles documenting the Sichuan earthquake investigation were published: 2,700 posts, thousands of photographs, and millions of comments were deleted by authorities.

Beaten by the police for trying to testify for Tan Zuoren, a fellow investigator of negligent construction and resulting student casualties during the Sichuan earthquake.

Suffers from a cerebral hemorrhage, linked to the police attack.

Designs stage set for the opera *Eine Florentinische Tragœdie* by Alexander Zemlinsky at Theatre Bremen, Germany.

2010 Jury member for Future Generation Art Prize, Kiev, Ukraine.

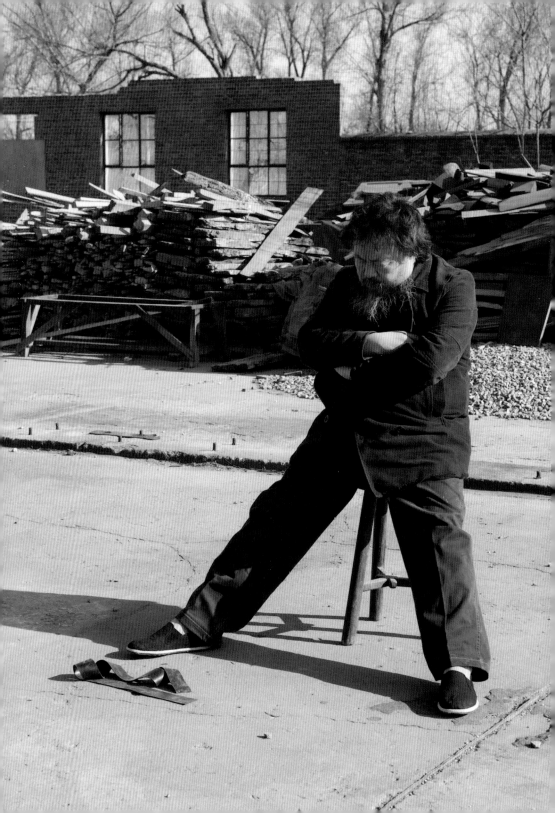

Selection of blog entries is published in Chinese, with English, German, Italian, and Portuguese to follow.

Designs Comme de Garçons store in Aoyama, Tokyo.

Participates in Digital Activism in China, a discussion with Jack Dorsey, co-founder of Twitter, and Richard MacManus, at the Paley Media Center in New York.

Moderates a talk with Nobel Prize winner Herta Müller at the international culture festival Litcologne, in Cologne, Germany.

The Unilever Series: Ai Weiwei, Sunflower Seeds in Turbine Hall at the Tate Modern, London.

Chinese police place him under house arrest for two days to prevent a party marking the forthcoming demolition of his newly built Shanghai studio.

2011 Shanghai studio is demolished in a surprise move by the local government on January 11.

Detained at the Beijing Capital International Airport and imprisoned without reason for 81 days on April 3. Police search his studio and confiscate the main computer's hard drive. He is prohibited from leaving Beijing without permission for one year.

Co-curator of the exhibition *Shanshui,* at The Museum of Art Lucerne, Switzerland.

TED 2011 conference speaker, Long Beach, California.

Member of Academy of Arts, Berlin, Germany.

Guest professorship at Oslo School of Architecture, Oslo, Norway/Beijing, China.

Jury member for UN Human Rights logo.

Co-director of the 2011 Gwangju Design Biennale, Gwangju, Korea.

Time magazine Person of the Year runner-up.

Wall Street Journal Innovators Award (Art).

Ranks number 1 on the *ArtReview* Power 100.

2012 The documentary film *Ai Weiwei: Never Sorry,* directed by American filmmaker Alison Klayman, receives the Special Jury Prize for Spirit of Defiance at the Sundance Film Festival.

WeiWeiCam, a self-surveillance project involving live 24-hour online feeds from his house and studio, is shut down by Chinese authorities 46 hours after the site goes live.

Opening of *Perspectives* at the Sackler Gallery in Washington, D.C.

Raises 9 million Chinese yuan (nearly $1.5 million) over social media as a deposit to appeal fabricated tax fraud accusations from the Chinese government.

Receives Václav Havel Prize for Creative Dissent from the Human Rights Foundation.

Elected as Foreign Member of Royal Swedish Academy of Fine Arts in Stockholm.

Honorary fellowship from the Royal Institute of British Architects, London.

Receives Cornell Capa Award from the International Center of Photography.

ArtReview ranks him number 3 in its annual Power 100.

Ai Weiwei: According to What? opens at the Hirshhorn Museum and Sculpture Garden, Washington D.C., then travels to several other North American museums, including the Brooklyn Museum in New York City, opening April 2014.

2013 Releases his first music album, *The Divine Comedy,* in June.

Exhibits the installation *Bang* in the German Pavilion at the Venice Biennale.

2014 Opening of *Ai Weiwei* exhibition at the Martin-Gropius-Bau museum in Berlin.

AI WEIWEI

Ai Weiwei, age one, with his father, Ai Qing, in Beijing, 1958.
Photo © Ai Weiwei.

Ai Weiwei's studio/house. Photo © Ben McMillan.

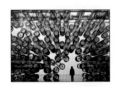

Forever Bicycles, 2011, 1,200 bicycles, 2628 × 957 cm. Photo © Ai Weiwei.

New York Photographs: Ai Weiwei, Williamsburg, Brooklyn, 1983.
Photo © Ai Weiwei.

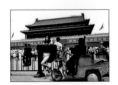

June 1994, 1994. Photo © Ai Weiwei.

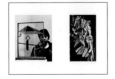

New York Photographs: In front of Duchamp's work, MoMA, New York, 1987.
Photo © Ai Weiwei.
Nude Descending a Staircase No. 2, by Marcel Duchamp, 1912.
Photo © The Granger Collection, NYC, all rights reserved.

Ai Weiwei studio exterior, 2008. Photo © Ai Weiwei.

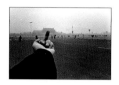

Study of Perspective: Tiananmen, 1995. This is the first of Ai Weiwei's ongoing *Study of Perspective* series, and it is the most significant one, as it was taken in Tiananmen. The finger making the gesture is Ai Weiwei's, signifying his questioning the random nature of power. Photo © Ai Weiwei.

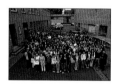

Fairytale, 2007, 1,001 visitors at Documenta 12, Kassel, Germany. In an unprecedented conceptual art work, Ai Weiwei brought 1,001 Chinese people who had never been abroad to the small German town during its influential Documenta exhibition. A colossal gesture to show both the need to connect people and the concept that experiencing other cultures expands the mind. Photo © Ai Weiwei.

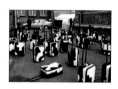

Fairytale Luggage, 2007, fabric, plastic, steel. Photo © Ai Weiwei.

New York Photographs: At the Museum of Modern Art, 1987. Photo © Ai Weiwei.

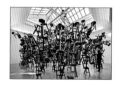

Bang, 2010–13, 886 antique stools, 11 x 12 x 6.7 m. Photo © Ai Weiwei.

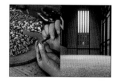

Making of Sunflower Seeds, 2008–10, Jingdezhen, China. Detail of the making of the 100 million porcelain sunflower seeds for the installation *Sunflower Seeds* at the Tate Modern in London. An entire village in China, Jingdezhen, was devoted to their production. Photo © Ai Weiwei.
Installation of *Sunflower Seeds* at the Tate Modern in London, 2010, 100 million porcelain sunflower seeds, paint. Photo © Tate Photography.

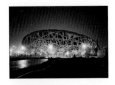

Olympic Stadium, 2005–08. Photo © Ai Weiwei.

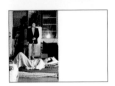

New York Photographs: Wang Keping & Ai Weiwei, 1987. Photo © Ai Weiwei.

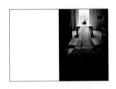

Lu Qing at work. *Untitled*, 2000, acrylic on silk, 4670 x 82 cm. Photo © Ai Weiwei.

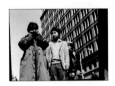

New York Phototgraphs: Mirror, 1987. Photo © Ai Weiwei.

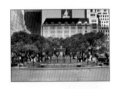

Circle of Animals/Zodiac Heads, Pulitzer Fountain at Grand Army Plaza, New York, 2011. Photo © Ai Weiwei.

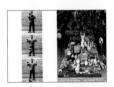

Dropping a Han Dynasty Urn, 1995. This powerful self-portrait photograph triptych is a symbol of Ai Weiwei's constant transformations both in his life and work. By purposely smashing the 2,000-year-old historical artifact, he rejects the sociocultural beliefs of China's past, specifically that of Han dynasty doctrine, and announces his life change from antiques dealer to artist. Photo © Ai Weiwei.
Panjiayuan Antique Market, where Ai Weiwei used to study and buy Chinese antiquities. Photo © Alex Ekins/Alamy.

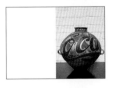

Coca-Cola Vase, 1997, Neolithic vase (5000–3000 BC) and paint. Ai Weiwei dialogues with the past by transforming with apparently simple and iconoclastic gestures precious artifacts such as this Neolithic Age vase, turning it into contemporary fine art by covering it with a Coca-Cola logo. In doing so he questions the past, replacing historical significance with a newer cultural one. Photo © Ai Weiwei.

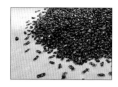

He Xie, 2011, porcelain, dimensions variable. Photo © Ai Weiwei.

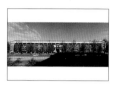

Remembering, 2009, 8,738 backpacks on metal structure. Photo © Ai Weiwei.

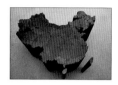

Map of China, 2009, ironwood (Tieli wood) from dismantled temples of the Qing Dynasty (1644–1911), 95 × 120 × 100 cm. Photo © Ai Weiwei.

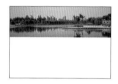

Panoramic view of Chaoyang Park, where Ai Weiwei enjoys taking walks. Photo © Bridget Colla.

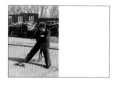

Ai Weiwei, 2013, from "Where I Work" in *ArtAsiaPacific* magazine, May–June 2013. Photo courtesy of Christopher Doyle and *ArtAsiaPacific*.

ACKNOWLEDGMENTS

This book would not have been possible without the generous collaboration of the Ai Weiwei studio, in particular Ai Weiwei's personal involvement, Marlene von Carnap's artistic guidance, and the support of Jennifer Ng.
Furthermore I am grateful to my publisher Martine Assouline who has a unique vision for art, and to the always impeccable vice president and editorial director Esther Kremer. Last but not least it has also been a privilege to count on the care of editor Amy Slingerland, photo editor Betsy Mullinix, and designer Cécilia Maurin. Finally I would like to express my gratitude to my dear, supportive Elena Foster, who introduced me to Ai Weiwei and his work at her art space in Madrid, Ivorypress.

—*Cristina Carrillo de Albornoz Fisac*

Assouline gratefully thanks Ai Weiwei and everyone in his studio for their gracious collaboration, especially Marlene von Carnap, and Cristina Carrillo de Albornoz Fisac. Assouline would also like to thank the following for their contributions to the book's imagery: Will Castro, Christopher Doyle, Ben McMillan, Elaine Ng, Hannah Rhadigan, and Gilles Sabrie.